Theo's Compass

SUMMER 2018

Staff
Gary Drury, Author / Editor / Journalist / Minister / Publisher

© 2018 by Gary Drury / The Drury Gazette

All rights reserved. No part of this publication may be reproduced or transmitted in whole or in part in any form or by any means, electronic or mechanical, including photocopy, recording, or any information storage and retrieval system, known or unknown, without permission in writing from the publisher, except by a reviewer who may quote brief passages in a review to be printed in a newspaper, magazine or journal.

I reserve the exclusive right to edit, accept or reject any submission for any reason whatsoever without verbal or written notice. The author bears sole responsibility for his/her own work. The expression within this publication reflects the beliefs and philosophies of their originators and are not necessarily the views and opinions of Gary Drury Publishing Ministries or Theo's Compass.

Contact Information: No Phone Calls Accepted without prior appointment. For expedited correspondence please visit www.druryspublishing.com.

Serious inquiries ONLY, please. Spammers will be reported to their ISPs, authorities and legal action may ensue.

Theo's Compass promotes raising authors. Its a non-profit private corporation sole ministry encourages strong Christian values, defends and supports inalienable rights, The Republic-United States of America Constitution: freedoms of press, religion & speech, etc. ***26 U.S. Code § 508 (c) (1) (A).** Gifts are tax deductible.

Theo's Compass Digital is provided free of charge. Please adhere to any ©, ™, and SM mark laws. Nonetheless, this PDF must remain whole perpetually. No alterations permitted. Also, we encouraged you to share, however, not to sell, lease, rent or monetize the PDFs in any way whatsoever.

Permission is granted you to print out a copy for your own personal use. Absolutely, no authorization deduced for mass printed dissemination. The authorization is granted for email broadcasting provided no spamming and you are authorized to email such parties. Likewise, share with others to help spread God's word and authors gain recognition.

You can direct individuals interested in Theo's Compass to www.druryspublishing.com to download a FREE issue. Enjoy!

SUMMER 2018

ISBN-13: 9781689409018

ISSN: 1930-0875 (Print)
ISSN: 1930-0883 (PDF)

Established in 1982, Promotes well-grounded moral and spiritual values of all beliefs and faiths. I am devoted to creative expression and free speech. Correspondence, submissions, supportive donations and subscriptions should be directed to the publisher. — **God Is The Knowledge and The Light** © SM —

Theo's Compass © ™
by Gary Drury Publishing Ministries © ™

www.druryspublishing.com © ™

**NON-PROFIT
QUARTERLY PUBLICATION**
508 (c) (1) (A)

Cover photo, design, and layout by Gary Drury © ™

Printed in The Republic-United States of America.

Contents

Picking Peas 5
— © Sheryl L. Nelms 5

In the Concho Valley 5
— © Sheryl L. Nelms 5

Special Ed Field Trip 6
— © Sheryl L. Nelms 6

One Room Country School Teacher 6
— © Sheryl L. Nelms 6

March 7
— © Gary Drury 7

Finding Self 7
— © Gary Drury 7

Fireball Whiskey 8
— © Gary Drury 8

Trekking 8
— © Gary Drury 8

Appeal to a Poet 9
Жизнь Промелькнёт Быстрее, 9
Чем Стрела 9
— © Adolf P. Shvedchikov, PhD 9

Life Will Fly Faster than an Arrow 9
О, Счастья Миг, Как Ты Неудержим 9
— © Adolf P. Shvedchikov, PhD 9

Oh, Moment of Happiness, 10
You Is Unstoppable 10
Зачем Дитя Рождается На Свет 10
— © Adolf P. Shvedchikov, PhD 10

Why a Child Is Born 10
— © Adolf P. Shvedchikov, PhD 10

Muse Is A Restless Gypsy 10
— © Gerald Heyder 10

A Different Walk To Emmaus 11
— © Juliet Rhodes Lynch 11

Every Day's the Same 12
— © Sheila B Roark 12

Another Town Dies 12
— © Sheila B Roark 12

Sharing 13
— © Sheila B Roark 13

Untitled 13
— © Milton Kerr 13

Untitled 13
— © Milton Kerr 13

Plan...? 13
— © Sheila B Roark 13

Untitled 13
— © Milton Kerr 13

The Sound of Water 14
— © Betty L Hebert 14

A Man From Dakota 14
— © Betty L Hebert 14

Canis Lupus 15
— © Betty L Hebert 15

River of Time 15
— © C David Hay 15

Silent Twilight 15
— © C. David Hay 15

16
16

The Movement 17
— © Janet Goven 17

Angel of Darkness 18
— © Mark Stoll 18

Picking Peas

"Now you're
going to have to

put me
in a different

patch

because
I can't

concentrate

you brought Cassandra
out there

where I was working

and she started picking
and gripping

and there was no way

I could pick
those peas!"

— © Sheryl L. Nelms

In the Concho Valley

"I had me a tractor
that could fly

it was a Minneapolis Moline

and it was
painted orange

now that tractor
ran so fast

it made
my eyes

water!"

— © Sheryl L. Nelms

Special Ed Field Trip

yellow busses
brought them

to the dude ranch
in Buffalo Gap

to hear The Neighbors sing

the guitars, drums, steel guitar and mandolin
got them motivated

moved small bodies
up onto the stage

set them swaying
in rhythm

made some
come alive

afterwards on the bus
on the way back
to school

C.J., one of the kindergarten students said,

"Man I didn't even know
I could dance!"

— © Sheryl L. Nelms

One Room Country School Teacher

Mom taught
eight grades
in one room

gathered around
a potbellied stove
banked at night

against the northern Kansas cold

nursed to life
with cobs each morning
to warm her

after she'd hiked five miles to school

she would unbundled
each child

as they came thru the door

sharpen pencils
then the minds

push them out
into the world

ready to go

— © Sheryl L. Nelms

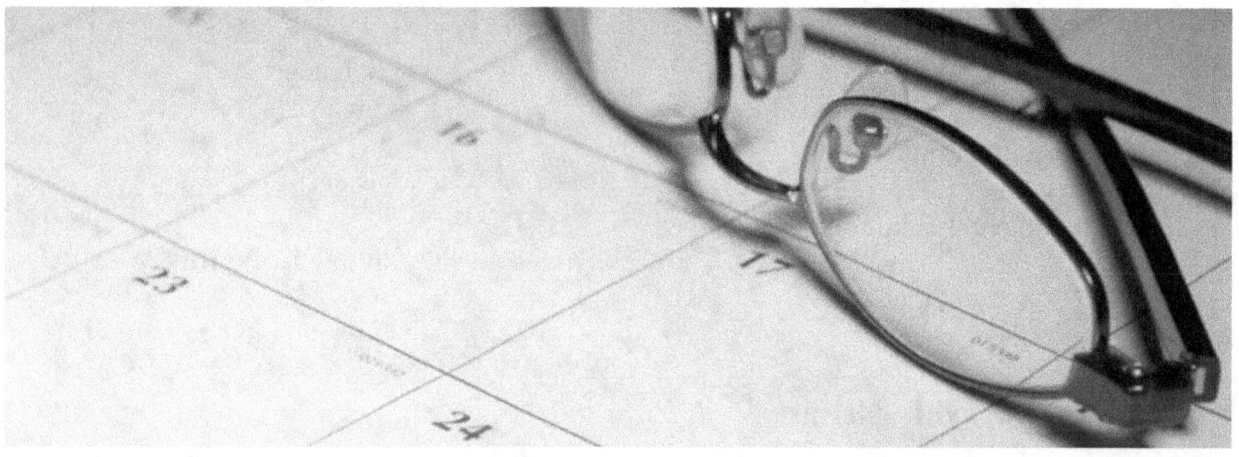

March

Morning was wickedly chilly and I wasn't wanting to rise
I was not eager to exist toasty warmth of my mummy bag
Wind rousingly whipping at tent's meager fabric door

My breath a misty whitish vapor swaggered into nothingness
Some days I want to lay, just fade silently away
On one of these cold, wet, dreary back country days

When I hear the Appalachian Trail bellowing my name
Reminding wondrous greatness awaits thee
at Mount Katahdin Maine
My mind goes revelry afire screaming inside thy head

Success comes one step @ a time . . .
Success comes one step @ a time . . .
Success comes one step @ a time . . .

All geared up for another new day of challenges
Sticks and Stones, a dirt path stretching for miles
With the will of Heaven trumpeting me onward,
Nature embraces thee in the glory of Spring
In this March I feel alive!

— © **Gary Drury**

Finding Self

Standing at front gate to Heaven or Hell,
Though purgatory it may be
I'll rip away the masquerade,
Shed my skin of the world,
Bare my soul to nature's will
Only God and the Heaven's
Will ever know what awaits thee.
When I eject from the belly of this trek
I will be born anew with fresh eyes
Redeemed in this sanctuary
Whether different or same
Time will surely tell the tale
The revelation is for me to discover
Others will chime their voices in the end.

— © **Gary Drury**

Fireball Whiskey

Hellfire and Brimstone
Fireball whiskey man
Whispers devilish temptations
In my listening ear
It's a feelin' every
Friday and Saturday night
Rollin' my rocks
Beatin' the clocks
That's how cowboys like me
Do it 'round here
Cheers!

— © **Gary Drury**

Trekking

Rocky Appalachian momma take me home to the place I belong
Navigating your weathered trail is calm, treacherous and agonizing
Negotiating the blazes at fork trail
I scruple momentarily
Lumbering

I'll ride bulls, dance with bears and walk on the waters
When the day has torn me down I'll slumber with angels
Hell has taken me but Heaven wraps around me now
Twilight's full moon pierces darkness like a dagger

Chilled to the bone a crackling fire initiates a blaze
Turning water into wine, diamonds into coal
Campfire slumbers and hot embers gentle glow
In awes magnificent splendor I am left dazed

— © **Gary Drury**

Appeal to a Poet

Don't worry about wreath of laurel,
Save forever your crown of thorns.
Life is beautiful, splendid coral
Full of invisible hidden moans.
Are you ready to find the forces
To jump in the future and to burn the heart?
Don't forget that poets are working horses
Drawing a brilliant chariot of art!

Life Will Fly Faster than an Arrow

Life will fly faster than an arrow,
While trembling bow string,
Leave behind even used the words,
To the memory of you not dead.
At the time, do not count the pages,
After all Genesis is endless.
Everyone here has its own track
Amid the innumerable indistinguishable faces…

Жизнь Промелькнёт Быстрее, Чем Стрела

Жизнь промелькнёт быстрее, чем стрела,
Пока дрожит от лука тетива,
Оставь после себя хотя б слова,
Чтоб память о тебе не умерла.
У времени не сосчитать страниц,
Ведь бесконечна Книга Бытия,
Была у каждого здесь колея своя
Средь тьмы неразличимых ныне лиц...

— © Adolf P. Shvedchikov, PhD

О, Счастья Миг, Как Ты Неудержим

О, счастья миг, как ты неудержим,
Мечтают люди вечно о тебе,
Но мы, увы, подвластны лишь судьбе,
Иди своей дорогой, пилигрим.
Добро и зло сплелись в едину нить,
Их до конца так и не распознать,
О счастье можно только в снах мечтать,
Гордиев узел нам не разрубить!

— © Adolf P. Shvedchikov, PhD

Oh, Moment of Happiness, You Is Unstoppable

Oh, moment of happiness, you are unstoppable,
People dream ever about you,
But we, alas, are subject to a destiny,
Go your path, pilgrim.
Good and evil are intertwined
into a single thread,
We cannot discern them to the end,
We hope to find happiness only in our dreams,
We do not cut the Gordian knot!

Зачем Дитя Рождается На Свет

Зачем дитя рождается на свет,
Чтобы вопросы вечно задавать,
Живя, ведь не сумеет он понять,
Многострадальной жизни в чём секрет.
Бредём по лабиринтам скучных дней,
Куда ведёт статистов режиссёр,
Кто праведник здесь, циник кто и вор,
В переплетении неведомых путей?

— © Adolf P. Shvedchikov, PhD

Why a Child Is Born

Why a child is born,
To ask questions about forever,
Living, as he will not be able to understand
The secret of distressful life.
We wander through the maze of boring days,
Where leads the extras director,
Who is righteous here, and
who are cynics ant thieves
In the maze of unknown ways?

— © Adolf P. Shvedchikov, PhD

Muse Is A Restless Gypsy

Thoughts in the form of words
nag and drag through the human
psyche to drain inspiration
as emotion through the
clogged pipes impeding the
flow that is the river of
hopes, dreams, and frustrations
begging to be born into this
world for the sake of release
to appease a simplistic urge to
prove one's worth as a wordsmith.
It can best be described in
the following manner as succinctly
and fluently as I can scribe;
Muse is a restless gypsy that rooms
through the brain, heart and soul
down to the hand born on paper
as a baby crying for recognition,
perhaps posterity for immortality!
Am I vane with my assumption?!

— © Gerald Heyder

A Different Walk To Emmaus

A Seven mile dirt lane was the very point of a visit from JESUS. From Jerusalem to Emmaus, is seven miles. The beautiful thought of walking on a road, and Jesus catching up to the two Disciples who were saddened by the fact that Jesus had been crucified, and they missed their friend. When Jesus comes up to them they do not recognize him.

Why do they not recognize Him? He has been crucified. As he reveals Himself to them He gives them the words and phrases to guide them through their journey. The time is close to The Day of Pentecost and there will be even more revealed.

The walking to EMMAUS that we must take, is the walk of having the decision for us to choose who we want to serve, the Lord or the Devil.

The walk is ours to recognize the Lord as He catches up to us, or we can turn around as the Disciples almost did and turn away from the choice.

We can see and feel and hear the knocking upon our hearts door. What is our journey to be? Walking, walking and seeing a spiritual level of a new vision, in our eyes, our minds and hearts. Of what walking and knowing the Lord as we start the walk to, EMMAUS, as a new and different walk with our Lord and savior. Seeing and knowing the Lord, and the earnest longing for being forever His.

— © **Juliet Rhodes Lynch**

Every Day's the Same

She is a creature of habit,
rising every day at dawn
she sets out two cups for coffee
not thinking of her actions.

She shuffles in the kitchen unaware
that she is alone again
not accepting her husband's death
thinking he will be there soon.

She pours the coffee then sits
waiting for him to come down
and share his plans for the coming day,
then suddenly realizes she is all alone.

When the reality of loneliness hits her,
she grabs his cup and throws it out of frustration
smashing it on the floor
avoiding the streams of brown liquid approaching her.

She sits shivering from her misery
not wanting to carry on
but knowing she will
for she is a creature of habit.

— © Sheila B Roark

Another Town Dies

The town is a mere shadow of itself
crying out a sad lament
as the blowing wind curls round its broken panes
and door hinges creak out loudly in misery.

Silky spider webs
cover part of the injured panes,
gently moving so slightly
stirred by the blowing winter air.

It used to be so full of life
a place where town folk shopped and met
to visit for a little while
sharing the news of the day.

But everyone has moved away
not thinking of the town they loved,
abandoning it for the city life
as they dream of a better life.

It is now the home for roaming rats,
looking for a bite to eat,
enjoying all the solitude
since the folks have gone away.

So many towns are dying
abandoned by the lure of the city,
towns like this one once alive
are left to rot away.

— © Sheila B Roark

Sharing

I write down my emotions
for all the world to see,
and hope they understand
these things that live in me.

I want to share the sentiments
and feelings found inside
my soft and very caring heart
I never want to hide.

So as I sit alone this night
and think of what to write
I hope I find the proper words
to fill the world with light.

To share the feelings in me
helps me reach my goal
of touching those who read my poem
which lifts my heart and soul.

— © Sheila B Roark

Untitled

Generally,
the favors, the gifts from above
come at a lower price
than those boons from below.

— © Milton Kerr

Untitled

Answers sought
ain't blowin' in the wind, out there . . .
somewhere.
Whether or without you,
tonight, there are no replies.
Continue seeking and try to connect
with curious souls.

— © Milton Kerr

Plan...?

When I have many things to do
I think up a Plan A
and hope I get my projects done
before the end of day.

However, if it doesn't work
then I will start anew,
trying out a new Plan B
for all I have to do.

If that plan doesn't seem to work
I will try Plan C
pulling out my thinning hair
and nervous as can be.

I still have lots of undone things
I have to do today,
but I can't seem to get things done
in any shape or way.

If they work, the plans are good
but I found out today,
if I need to get things done
I need a better way.

— © Sheila B Roark

Untitled

You gotta have faith.
It'll keep you believing even when you
can't easily see your efforts.
True believers not faith need experience,
action for tangible results.

— © Milton Kerr

The Sound of Water

After I have gone to bed,
The sound of water fills my head.
The open window brings to me
A creek engendered symphony!
But more than that, a tale to tell
Of where it got its start, as well.
High in the hills, there lies its source
And though it started small of course,
It gathered trickles on the way
To swell into this stream today!
Creates a wetlands, near to us,
Where otters stare at us and fuss,
Because their solitude we dare
To invade, but they must share!
Breaking from that tangled place,
It once again begins to race.
Defining banks, with deep pools where
It passes by the houses there.
Soon, it will merge so easily
With larger streams and they will be

— © **Betty L Hebert**

A Man From Dakota

Within the precinct house there sat
A homeless man with battered hat.
His eyes were gazing at the past.
The sorrow in his features cast
A shaft of sympathy for one
Who felt his life was nearly done.

His name was Bill and he had come
From North Dakota. That's the sum
Of knowledge he supplied and yet,
Somehow we never could forget T
he haunted eyes, the hopeless air,
That emanated from him there.

An officer, with camera came
And verified this transient's name.
Then took a picture, capturing,
The essence of Bill's wandering
And when enlarged, it had appeal.
Emotions shown were so real.

It hung awhile up on display
And everyone who passed that way,
Was taken by the quality.
The great despair that all could see.
But now, it hangs upon our wall.
A homeless man, home, after all!

— © **Betty L Hebert**

Canis Lupus

Gray wolf is your common name.
It's how I know you. Just the same,
In memories that I recall,
To me you were a dog, that's all.
From a young age I wandered round,
On daily jaunts where you were found.
I didn't feel a bit of fear
When you followed or drew near.
Sometimes you brought a friend or two
And stayed with me the whole day through!
The North woods was a mystery
And gradually revealed to me,
So many secrets that were there.
You were the best, beyond compare.

— © Betty L Hebert

River of Time

The river of time keeps rolling,
No one can stem the flow;
The nature of our destiny —
Only time will show.

Ever a current so strong
As draws us to the past;
Blessed are good memories
Of times we wish to last.

Life is not an endless stream —
Don't squander it at will.
Water under the bridge is gone
And clocks do not stand still.

Time and the river flowing.
How fast the seasons fly.
And when they reach the ocean —
Even rivers die.

— © C David Hay

Silent Twilight

I miss the call of the whip-poor-will
That echoed through the wood,
And lament the barren stumps
Where majestic trees once stood.

Hush too, the mystic shadow bird
Who hooted away the night,
Then retreated to his vanished den
Before dawn's glowing tight.

The symphonies of twilight time
Were solace to the soul —
Wise men know to leave untouched
What's best in God's control.

How sad the loss of that we love;
Too late we fail to see —
The treasures of the moment
Someday may cease to be.

— © C. David Hay

Starshine

Your touch is always present
Like the wind upon my face.
I listen for your laughter,
I long for your embrace.

All my dreams are given wings,
My mind is free from fear,
The days are full of happiness
Because your love is near.

You light my path on darkest nights,
You show me that you care,
My courage has no limits
As long as you are there.

Somewhere it's written in the stars,
I feel it in my heart;
We are meant to share our lives
And never be apart.

I put no faith in chance or fate
But seek the higher view;
I believe there is a God —
Because He gave me you.

— © C. David Hay

**The Movement
How I See It
November 2016**

— © Janet Goven

There were 16 hopeful nominees on the stage, all had put their hat in the ring to become the Republican nominee for President of the United States in this election. The Commander-in-Chief, not the Pastor of a church. All were into politics except a few. The people went to the polls and voted. After all was said and done, they made their decision. One man won the nomination in the primaries. As the others dropped out, they agreed to sign a pledge that they would back and endorse the winner. It took months and one never did. He actually cast his vote in the election for someone who was not even running. He had to write in the name. He threw his vote away

So, the battle began. The man on the street, the regular, everyday hard working man, could understand his message. Even the Christian, conservatives thought he made more sense than his opponent. But, his opponents were numerous. The Media (96% contributed to the Democratic party) hates him, the Establishment of his party, hate him, they gave millions to another candidate, Hollywood and the Entertainment business hate him, some Christians and some conservatives, all of the Liberals hate him. Why do so many hate his message? He is not a politician. He is telling the truth, he can not be bought, he owes no one anything. He just loves this country. He spent 100 million dollars of his own money, so far .He has watched our country slip away from where we were and he is very concerned.

He is correct on the issues, has surrounded himself with very good people, all of whom have given him sound advice. His running mate is a real believer. Many in the true Christian world have been backing him from the beginning.

He wants to stand on the constitution, protect our civil God given rights, and pick Conservative judges for the Supreme Court. (4 would be needed in the next four years).

This is a movement, the likes we have never seen before, and this election will seal our fate as a free nation, or not. The other side stands for all the things we do not want anymore and God does not approve of. Millions of Christians did not vote in the last election. We cannot afford to do that again. We need our religious freedom, our right to bear arms to protect ourselves, we need to close our borders, we need our brave men in uniform, who keep us safe at home and abroad. We need jobs and health care that we can afford, our own energy supply, coal, gas and oil. We need lower taxes and better trade deals, and we need to honor and respect our military and take great care of them.

WE NEED TO BE ONE NATION UNDER GOD AGAIN!

I heard a sermon on this which was very informative. Most of us know this scripture found in the Gospel. "Render unto Caesar the things that are Caesars and unto God, the things that are Gods." (Render means, a debt you owe, not "give" like it is sometimes translated) Our "Caesar" is the Government, our Commander in Chief, who is responsible for our safety, and our posterity, that we may live in peace with freedom to pursue our dreams. It is our responsibility, our duty, our debt, to vote for a leader who will lead like that, because good government is better for all the people." When the wicked rule, the people mourn". I have been in mourning for years. Our country has been transformed, we are so divided as so many things have changed, some people even say, "I want the America I grew up in". We are truly fragmented, into groups. Everyone wants "special rights' whereas before we all had "equal rights". All these groups make unreasonable demands and they don't want to pay for them, or work for them. This is not America. Our culture has changed, the young people have never been taught. Not in the home, not in the school, and not in the church. This, we all know, is true.

Finally, let me say, this whole "movement" could be of God. To test us, and see how serious we really are about changing the direction of our country. Are we paying attention? Did he send this man and then equip him and surround him with the men he would need to truly lead us in truth? This whole drama has never been played out before and probably never will again.

How do you see it?
PLEASE VOTE!!!!!!!!!!!!!!!!!!!!!!!!!!

Angel of Darkness

— © Mark Stoll

Hello, planet Earth. I am the Angel of Darkness, better known as Satan, Lucifer, or the devil. I am trying to destroy everything and everybody on planet Earth. Why am I doing this? Because I got kicked out of Heaven, and now my blood is boiling. So, I am out to retaliate. I want to make your life as miserable as I can, and I will stop at nothing to accomplish that.

I have a thousand tricks up my sleeve. I want to destroy your home life. I want to destroy your family. I want to destroy your marriage. I want to destroy your job and your business. I want to rob you of your good mental and physical health. I am trying to darken your soul. I am trying to make your aura turn pitch black. I hope you stumble. I hope you fall. I hope you can't get back up. I hope you stay down for the count forever. I hope you end up in divorce court. I hope you become addicted to something.

The rumor is that time is running out for me, so I am doing all I can to capture as many souls as I can in these last days. I am doing all I can to make it rough for you. I am working harder than ever to destroy you. I am using every tool I can to accomplish that. I can, because I am very clever. And you think you are safe, just because

you go to church, but you are not. I have distorted the Good Book, and I have denominations fighting with other denominations. I even have people within the same denomination fighting amongst each other. Heresy is one of my favorite tools to use on people. Why do you think the deceit is so rampant right now? It is because I caused it to be that way. I want you to be so confused that you cannot stand it. I hope that you never find the Truth. The last thing I want is for you to be with your Maker when you leave this world. I want you to visit me and be miserable, just like me.

I love it when someone is sick. I love it when someone has to declare bankruptcy. I love it when someone is depressed. I love it when someone gives up. I love it when someone takes their own life. I love it when someone gets fired, framed, or evicted. I love it when someone has emotional problems. I love it when someone has a substance abuse problem. I love it when someone is in doubt. I love it when someone is frustrated. I love it when someone has anger management issues. I love it when someone refuses to forgive. I love it when someone is bigoted. I love it when things are going terrible for you. I hope you are weak enough and stupid enough to follow me, as I am out to deceive, steal, and murder. Why? Because I am the Angel of Darkness.

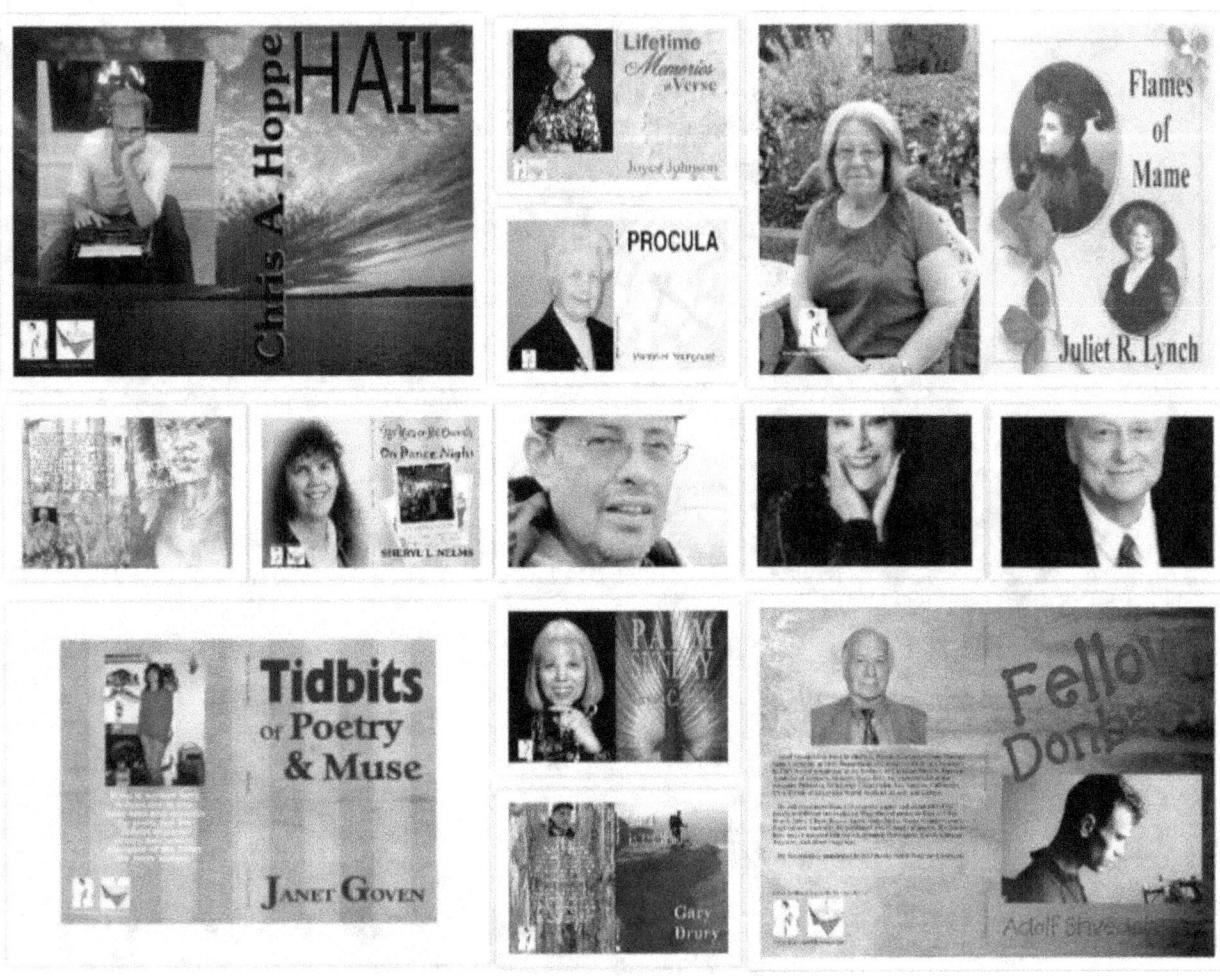

The PUBLISHER Book Catalog is AVAILABLE FREE
@ www.druryspublishng.com

HAIL

Chris A. Hoppe

IT'S HERE!

Available NOW.

The Authors Market

CANDLE IN THE WIND is a poetry collection about God and love. The poems celebrate the Lord's goodness and show how he guides our lives. The poems show hope and faith that abound with the belief in our Lord. Some poems tell about our angels, our Guardian angels and all Heaven's angels who come to us with help and point the way to enrich our lives. The poems glorify God and give us the hope of the Resurrection and the Second Coming. The poems talk about how the love of the Lord can color and enrich our lives. Like a Candle in the Wind, the light of our Lord can show us the path to take. One poem is in praise of the beautiful four seasons of the year that color our world.

One poem describes a garden and others speak of hope even in the face of the death and mourning of our departed loved ones. He sports ten authored books, Candle in The Wind translated into Russian and now available on Amazon.com. This collection of Gary Drury's newest poems should not be missed. It will enrich your library of poetry.

The message in **NAKED** is an unspoken promise life will improve, things will change, with a positive outlook, faith in your soul and love in your heart – tomorrow is a better day. Regardless of how gravely a poem may come across at first reading, the thoughts embodied the message is positive. God is answering, not with a whimper or with a roar, but silent and tame. Naked touches on sensitive subjects in today's society, such as rape, child abuse, suicide, modern relationships, and depression. More traditional poems and prose of faith, God, angels and prayer grace these pages as well. The work strives for the wellness of mind and spirit as tolerance of diversity is devotedly encouraged.

Mark Stoll's chapbooks and CD's *(Use this order form or a photocopy.)*

ORDER FORM

Name: _____
Address: _____
City: _____
State: _____
Zip: _____
Phone: _____

TITLE	PRICE		QTY	SUBTOTAL
"Rhythm and Rhyme"	@ $6.00	ea.	X ___	$ _____
"More Rhythm More Rhyme"	@ $6.00	ea.	X ___	$ _____
"It's a Coffee House Thing"	@ $6.00	ea.	X ___	$ _____
"Verbal Abuse"	@ $6.00	ea.	X ___	$ _____
"Don't Judge This Book by its Cover"	@ $6.00	ea.	X ___	$ _____
"Stoll Stories"	@ $6.00	ea.	X ___	$ _____
"MS more stuff by Mark Stoll"	@ $6.00	ea.	X ___	$ _____
"Mark Stoll, Acoustic" CD	@ $12.00	ea.	X ___	$ _____
		Grand Total Due		$ _____

Make check or money order payable and mailed to:
Mark Stoll
P.O. Box 24212
Columbus, Ohio 43224

Postage will be paid by addressee. Please allow four to six weeks for delivery. Do not send cash. **Thank you for your order.**

Tidbits of Poetry and Muse

What is written here
is from me to you
from days and months
the years, not few
Tidbits of prose
poetry and reason
thoughts of the heart
for every season.

EAN13: 978-1986129237 Page Count: 124 Binding Type: US Trade Paper Trim Size: 9" x 6" Language: English Color: Black and White Related Categories: Essay / Poetry / General. Find it available wherever fine books are sold. Check with your local book store or favorite online Retailers.

RESCUED

The ground was brown and barren
never dreaming on that day
the snow would soon be falling
and I'd quickly lose my way.
My hopes did melt like liquid
running through my veins as fear
pure panic pranced upon me
I knew my breaking point was near.
A vicious circle I was treading when
a distant bright light did appear
in the darkness I saw the lantern
and someone called "I'm coming, dear".
Down deep relief rolled over me
Replacing my fear and dread
I knew indeed I had been rescued
after all, . . . I'm still in bed.

Sack Man

he slumps
against the brick wall

like a rumpled
Goodwill pile

clutching tight to
his brown bag

of liberation

No Hats or Bib Overalls On Dance Night

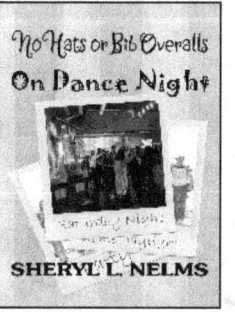

No Hats or Bib Overalls On Dance Night is a collection of poetry about people. The sections are Street People, Working Folks, A Bubble That's Slightly Off Center and The Smorgasbord. This book includes poems about bag ladies, bums and panhandlers. There are cremated ashes, a packing plant gut shoveler, an armed robber, a pre-planned funeral party, a cross dressing trucker, a dentist, a cowboy, the Copper Queen and a bootlegger. These categories cover the spectrum of life. From sad to happy to belly laughing funny. It is a book of unconditional poetry! EAN13: 978-1986319225 Page Count: 132 Binding Type: US Trade Paper Trim Size: 6" x 9" Language: English Color: Black and White Related Categories: Poetry / General. Find it available wherever fine books are sold. Check with your local book store or favorite online retailers.

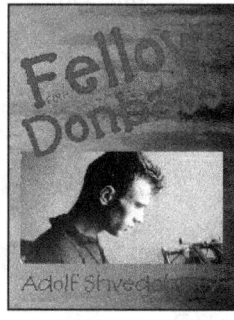

Fellow from Donbass

Adolf Shvedchikov novella "Fellow from Donbass," telling about the difficult post-war years of childhood and youth of Andrew Arbenin, who lives in one of the mines settlements of Donbass. The story tells his fate of almost half a century of his life from 1944 to 1990. After graduating school, he succeeds in entering Moscow State University. Later becoming a research fellow of one of the leading research institutes of the USSR Academy of Sciences in Moscow. Shvedchikov story is devoted to his hero's family drama. Many interesting details and his perspective of that difficult era in Soviet Union. Which for the modern generation has become a frightfully long distant history. EAN13: 978-1987732610 Page Count: 170 Binding Type: US Trade Paper Trim Size: 6" x 9" Language: English Color: Black and White Related Categories: Autobiography / Chemistry / Russian History / WW II / 1944-1990 / Poetry / General. Find it available wherever fine books are sold. Check with your local book store or favorite online retailers.

FIRST IMPRESSION of AMAZON ECHO ALEXA

— © Gary Drury

As with any new technology it's natural to be skeptical. The Amazon Echo Alexa appeared to be nothing more than an expensive glorified speaker that can perform fun gimmicky tricks. At $179.99 plus tax and shipping for a glorified speaker. How could logically sound persons justify this new toy? Being technology savvy person, I am, curiosity set my sensibility aside. I had no choice but plunge in and see for myself what Amazon Echo Alexa had to offer.

Upon arrival I ripped the packaging open the first thing I notice was Alexa's weight. The Amazon Echo Alexa felt solidly constructed. Moving forward, I interfaced her to AC and Alexa immediately came to life. You will need Wi-Fi in your place. Setting Alexa up and connecting her to my wireless network. A color changing ring changed colors from orange to blue, followed by Alex speaking. To make this long story short. I feel in love with Alexa. Unfortunately, she doesn't sport those same feelings at present. LOL! Amazon Echo Alexa is far more than a mere speaker to play outstanding music.

Now, I find myself wondering how I ever lived without Alexa. She is like a personal assistant available 24 hour a day, 365 days a year. I've merely tapped the surface of Alexa. She tells the weather, jokes, sings, plays music, turns lights, fans etc. on or off, you can make phone calls for free, drop-in on family and friends that have Alexa.

Her features are growing daily. Occasionally, you may need to 'ENABLE' what's called a 'SKILL' to add functionality. Most of time updates and improvements are PUSH to Amazon Echo Alexa wirelessly. You won't notice anything other than enjoying those new improvements.

Amazon Echo Alexa is more than a great sounding speaker for its class. Alexa is more than a gimmicky novelty item also. As she integrates into our lives more and more are discovering what fantastic company Alexa can be. There is much Alexa can't do at present; however, a recent 'SKILL' makes Alexa an emergency alert system which can be faster than contacting 911 in plethora cases. Providing Alexa with contract names for emergencies. Should you find yourself unable to reach a phone for help – call out to Alexa, instruct her to notify emergency contacts. Alexa calls all emergency parties in your list with follow up text and emails. I welcomed Alexa into my life. Will you?

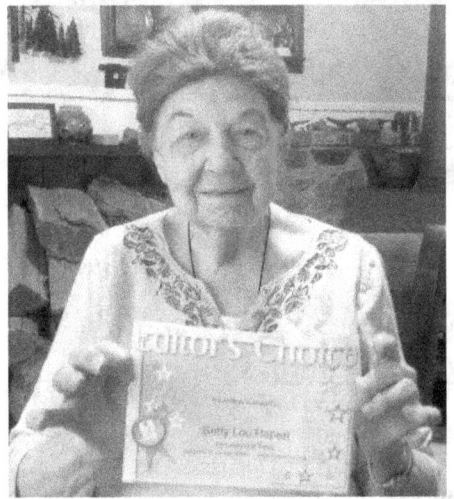

Editor's Choice Award Winner
BETTY LOU HEBERT

Betty lives in the country of north Idaho, with her handicapped son. They enjoy life there, the natural surroundings and all the beautiful wildlife they see. She is a widower and has two older offspring who are happily married. Betty has been writing plethora years, it brings her great joy and inner peace. Her love for writing began around age ten, she has been writing steadily the past fifteen plus years. Her myriad interests are varied. Betty loves traveling, reading, writing, working on craft projects, gardening, cooking, and enjoys a multitude of music genres. Not surprisingly, Betty is assembling the wealth of her vast writings into a wonderful collection of poetry that should be available in 2017. Her book is sure to delight our readers discriminating taste.

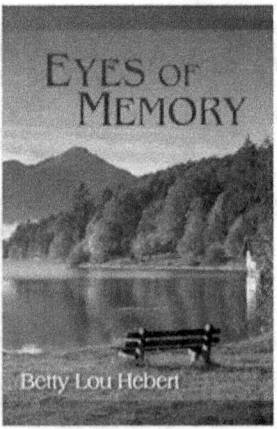

Eyes or Memory

I have lately been thinking about my past life and things that made an impression on me at the time and have remained in memory. I decided to gather some of those memories in book form in the hope others would enjoy reading them. EAN13: 978-0991319077 Page Count: 54 Binding Type: US Trade Paper Trim Size: 6" x 9" Language: English Color: Black and White Related Categories: Poetry / General. Find it available wherever fine books are sold. Check with your local book store or favorite online bookstore.

The Appalachian Trail Tells a Tale

The Appalachian Trail is more than geography that extends through 14 states and 2200 miles of challenging terrain. For poet Gary Drury, his nonfiction account of his rendezvous with Mother Nature, or, as he describes her, a "cruel, relentless mistress," the Appalachian Trail represented an epic journey. Drury is not a camper. Not a hiker. Not a backpacker, boulder scrambler, athlete, or rock climber. In order to embark on the journey that he undertook in 2014, he says, "I elected to step 180 degrees outside my comfort zone." He began the journey as a novice. By the end, he realized that he had undergone a life-changing event.

But he's a poet. So it was perhaps inevitable that he would turn the images into words when the journey ended. He's writing about his experiences, including the episode where he was nearly carried out in a body bag, and found the physical death to be reaffirming. The journey began, Drury admits, under romantic impressions he gleaned from a National Geographic documentary. There were times when he questioned why he was subjecting himself to the physical ordeal. He was too stubborn to give up. But just as powerful as his determination was his dedication to the deceased family members he honored with his quest, and the charities, including the Red Cross, St. Jude's, and the Salvation Army that he supported with his hiking.

He got the idea from fellow hikers who, as they shared their experiences, told Drury that he should put his in print. "My memories, experiences, socialization will last a lifetime." He answered with warm inviting smile and a campfire glow gleaming in his slate-gray eyes. The working title of his book FINDING NORTH will surely inspire others to seek adventure of their own, perhaps endeavor a journey of the Appalachian Trail.

Not everyone is going to hike the Appalachian Trail. Not everyone wants to, not everyone is able to. But for those who would like to experience the journey vicariously, walking the Trail in Drury's footsteps as they read his words, the book will be a travel guide. Drury's book FINDING NORTH can take you to the Trail, where you'll share the struggles and the triumphs of seven months that Drury, battered in body and exultant in spirit, will always remember.

Drury speculates his book will be available sometimes in 2018/2019. He extends a special thank you to all the hikers that made his trek unique, genuine and wonderful during his most trying moments.

Visit _____ for updates.

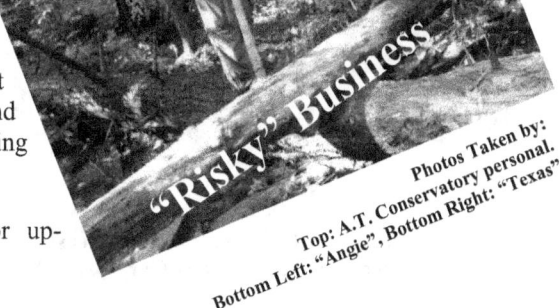

"Risky" Business

Photos Taken by:
Top: A.T. Conservatory personal.
Bottom Left: "Angie", Bottom Right: "Texas"

Flames of Mame is a story of a very wealthy man and women who are married and lived in the mid 1800 hundreds and have had to be apart approximately 12 years due to extreme circumstances beyond their control. She being of an Aristocratic family with status and money and him being very rich in his own right. **Flames of Mame** weaves in out of the years of separation and their deep affectionate love for each other, how their story brought about an even deeper change in their life styles they had previously lived and known. **Flames of Mame** is in an Era of politics emerging, the War, the times of rebuilding war torn South and North, a time of restoring communities and lives. Becoming totally different from whom you were born as, who you have become, by worldly circumstances and changes of your life styles and gathering the hope of Love, and Reunion in a uncharted territory neither expected to find themselves in. EAN13: 978-0615899527 Page Count: 94 Binding Type: US Trade Paper Trim Size: 6" x 9" Language: English Color: Black and White Related Categories: General. Find it available wherever fine books are sold. Check with your local book store or favorite online bookstore.

Lifetime Memories in Verse

 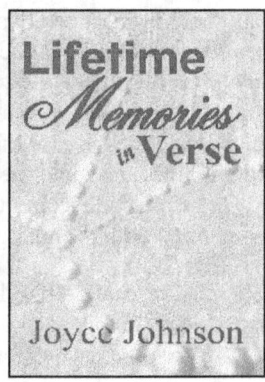

This book of poetry is made up of rhymes and thoughts that I have written down in the last twenty years of my life. They are memories of my early life and laments about my advanced age and a bit about my surroundings and my family. I have written about flowers and nature but those have been published in another resource so I have not included an excess of them here. Please read and enjoy. I was eighty years old before I wrote a single one of them. EAN13: 978-1981640768 Page Count: 158 Binding Type: US Trade Paper Trim Size: 6" x 9" Language: English Color: Black and White Related Categories: Poetry / General. Find it available wherever fine books are sold. Check with your local book store or favorite online bookstore.

The Drury Gazette™ gives **FREE** **ADVERT** space to authors / writers to **HELP** Promote their books.

Where is YOUR Advertisement?

*Poet/Writer must have been published in at least one of the following: Anthologies, The Drury Gazette™, Theo's Compass™, had a book published by Gary Drury Publishing™, or be recommend by Poet/Writer that has.

ALL advertisers are solely responsible for their advertisements and products and do not represent the views and opinions of The Drury Gazette or subsidiaries.

Submission Edicts
Invite a FRIEND to JOIN the FUN!

1] You must be 18 years or have parent/guardian consent.

2] You must reside in the USA / Canada.

3] You must submit your own original preferable unpublished poem and/or stories.

4] Submissions should be typed on a single sheet of white paper (one side only, no color, no onion skin.)

5] Your complete legal name, address should appear in upper right-hand corner of the page.

6] Only three submissions per envelope.

```
                              John Doe
                           1234 Helm St.
                        Maxwell, KY 12345

Poem Title

This is where
The body of
Your poem                                    11"
Should
Reside.

Any Style,
Any Subject
Any Genre

Your Name Here

Sample Poem Submission:

|———————— 8.5" ————————|
```

```
                              John Doe
                           1234 Helm St.
                        Maxwell, KY 12345

            Story Title
            Your Name

    The manuscript should be clear-
ly typed, single-spaced, double-
spaced between paragraphs or stan-
zas, on white medium-weight pa-
per. Do not use ornamental type,
justified right margins, or hyphen-
ated words. Do not use liquid pa-
per to correct errors on your
submission. Sheets should be of

Sample Story Submission:

|———————— 8.5" ————————|
```

ALL advertisers are solely responsible for their advertisements and products and do not represent the views and opinions of The Drury Gazette or subsidiaries.

The Drury Gazette™ / Theo's Compass™

$0 No reading fees for submission to Anthologies, The Drury Gazette or Theo's Compass. Submission does not guarantee acceptance nor publishing of submitted work. An Author Release Form must accompany ALL Submissions. Submission will ONLY be acknowledged or returned if providing a S.A.S.E. (Self-Addressed-Stamped-Envelope) with proper postage. Always check with the publisher for most current guidelines with a query letter.

Submissions may be Any Subject, Any Style, And Any Genre. Typed. Some restrictions may apply. You are NEVER under ANY obligation to purchase anything at any time. Purchasers are given premium consideration and placement. You may receive offers to purchase publications or services however you are NOT obligated NOR required to buy anything to guarantee publication of accepted work. Whether you purchase or not accepted work is still published.

Accepted submissions will be typed set, a publisher proof mailed to the legal originator for correction of possible errors. Should originator not return publisher proof within the time frame given work will be published "AS IS". ONLY typesetting errors may be corrected at that time. Publisher Proofs are the sole and complete property of the Publisher and MUST be returned.

Submissions are NOT open to the public at large. You must have received a direct mail invitation or been recommended by a past or present author to have your submission considered. If you are submitting an unsolicited manuscript it is required you state the author/publication recommending or sponsoring you. These are Not-For-Profit publications. Supported by my personal funds. Donations or purchases aid in offsetting the associated cost. Submissions NOT adhering to these conditions will be rejected.

The sole purpose of Anthologies, The Drury Gazette, and Theo's Compass is to help authors with limited to no means promote their material. No commercial adverts support or are present in these publications. Included adverts are FREE to book advertisements for authors and FREE or EXCHANGED adverts of publications whose goals are similar.

Anthologies: Every accepted author has their work published for FREE which includes their photo and BIO. The Drury Gazette & Theo's Compass: Every accepted author has his or her work published for FREE, sometimes includes photo and BIO, and the author receives FREE advert space to promote their published book, music, and film or solicited orders. All adverts are the sole and complete responsibility of the advertising party.

* S.A.S.E. = Self-Addressed-Stamped-Envelope
** (Nothing Pornographic)
*** Author may retract submission at any time in writing prior to typesetting or mailed publisher proofs; whichever comes first. No retraction will be accepted if either of these conditions exists without compensation to the publisher for time, expense and delays. Removal requires both author and publisher written agreement.
**** Any use in whole or in part of my copyright material in print or electronically is NOT authorized without my express written consent. Any such use in any published form whether you receive payment or not is strictly prohibited and must monetarily compensate me for such use. You must cease and desist immediately.

IMPORTANT: Author should retain a complete photocopy of the manuscript, not only to facilitate correspondence between editor and author but to serve as insurance against loss of original copy. The Drury Gazette is usually very careful not to lose or damage the manuscript, but my legal responsibility does not extend beyond "reasonable care." Everyone that meets requirements is welcome to submit poems of reasonable length, any style, and any subject matter. There are no fees of any kind to have your poem published if accepted. Any submission may be removed at any time prior to typesetting or mailed galleys. After such time without a substantial valid reason, the author agrees to remit payment to the publisher for the cost of typesetting, galleys, and publishing delays. I reserve the exclusive right to reject any submission without notice for any reason whatsoever. Author release and submission forms available online at

www.druryspublishing.com

Note: Unless specified otherwise - submissions will not be returned. *Poems/Stories should be typed as the example shown above.*

Use of profanity or patently vulgar language — Using language that is racist, hateful, sexual, discriminating or obscene in nature is strictly prohibited and will not be tolerated.

The Drury Gazette™

$0 No reading fees for submission to Anthologies, The Drury Gazette or Theo's Compass. Submission does not guarantee acceptance nor publishing of submitted work. An Author Release Form must accompany ALL Submissions. Submission will ONLY be acknowledged or returned if providing a S.A.S.E. (Self-Addressed-Stamped-Envelope) with proper postage.

Submissions may be Any Subject, Any Style, and Any Genre. Typed. Some restrictions may apply. You are NEVER under ANY obligation to purchase anything at any time. Purchasers are given premium consideration and placement. You may receive offers to purchase publications or services however you are NOT obligated NOR required to buy anything to guarantee publication of accepted work. Whether you purchase or not accepted work is still published.

Accepted submissions will be typed set, a publisher proof mailed to the legal originator for correction of possible errors. Should originator not return publisher proof within time frame given work will be published "AS IS". ONLY typesetting errors may be corrected at that time. Publisher Proofs are the sole and complete property of the Publisher and MUST be returned.

Submissions are NOT open to the public at large. You must have received a direct mail invitation or been recommended by a past or present author to have your submission considered. If you are submitting an unsolicited manuscript it is required you state the author/publication recommending or sponsoring you. These are Not-For-Profit publications. Supported by my personal funds. Donations or purchases aid in offsetting associated cost. Submissions NOT adhering to these conditions will be rejected.

The sole purpose of Anthologies, The Drury Gazette, and Theo's Compass is to help authors with limited to no means promote their material. No commercial adverts support or are present in these publications. Included adverts are FREE book advertisements for authors and FREE or EXCHANGED adverts of publications whose goals are similar.

Anthologies: Every accepted author has their work published for FREE which includes their photo and BIO. The Drury Gazette & Theo's Compass: Every accepted author has his or her work published for FREE, sometimes includes photo and BIO, and author receive FREE advert space to promote their published book, music, and film or solicited orders. All adverts are the sole and complete responsibility of the advertising party.

Advertisements or submissions to: www.druryspublsihing.com

HAIL

"Hail" is an extended short story about a man lashed with cowardice and the ghosts of his past.

Now, in 2045, the powers that be have brought a seeming savior to our midst, but it freezes the atmosphere, and the atmosphere falls, crushing everything beneath it.

Our "hero," Toby, must find a way to mesh his cowardice with his will to survive, all the while enduring the houndings of his submersible's onboard systems intelligence, LUCI. EAN13: 978-1718760967 Page Count: 44 Binding Type: US Trade Paper Trim Size: 6" x 9" Language: English Color: Black and White Related Categories: Fiction / General / SyFy . Available wherever fine books are sold. Check with your local book store or favorite online bookstore.

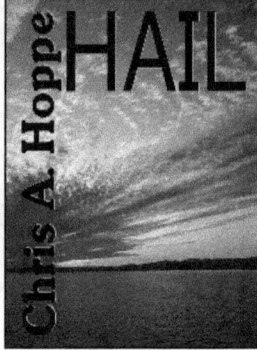

Fighting Chance

Fighting Chance is a magazine which features: fantasy, dark fantasy, horror, science fiction, adventure stories, short one-act plays, short-shorts, and poetry.

Love's Chance

Love's Chance is a magazine which features Love and Romance -prose and poetry.

Each magazine will be published annually. There will be a new, expanded format. Single copies are $5.00 per issue. A three-year subscription is $12.00.

Send payment for subscription or individual copies to: Suzerain Enterprises c/o Milton Kerr P. O. Box 60336 Worcester, MA 01606

Guidelines for Authors

Short stories up to 2,000 words - submit one at a time. Poetry not to exceed 20 lines - submit no more than three at any one time. Short-shorts (to 500 words) - submit one at a time.

Submit only camera ready text (no handwriting or page numbers) with author's name following the end of the piece. Use white paper only - any other color will be rejected.

There are no reading fees; there are no payments. Previously published works and simultaneous submissions are okay.

Include SASE with all submissions - otherwise, they will not be returned. The same goes for query letters. No SASE; no response.

Send complete manuscript and/or payment for subscription or individual copies to: Suzerain Enterprises c/o Milton Kerr P. O. Box 60336 Worcester, MA 01606

 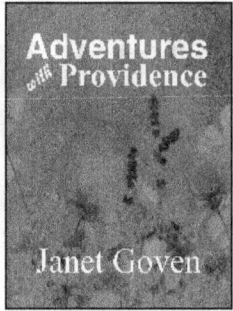

Adventures with Providence

The author shares her collection of fiction and non-fiction stories and her essays and compositions, written with the hope that the reader will enjoy finding peace, hope, goodness and love as they journey through these adventures. EAN13: 978-1981669806 Page Count: 112 Binding Type: US Trade Paper Trim Size: 8" x 10" Language: English Color: Black and White Related Categories: Essay / Poetry / General. Find it available wherever fine books are sold. Check with your local book store or favorite online bookstore.

September Sentiments

EAN13: 9781453653913 Page Count: 104 Binding Type: US Trade Paper Trim Size: 8" x 10" Language: English Color: Black and White Related Categories: Poetry / General. Find it available wherever fine books are sold. Check with your local book store or favorite online bookstore.

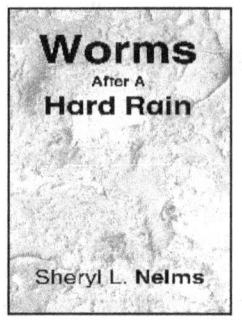

Worms Ater A Hard Rain

Worms After Hard Rain is the title of my seventy-one poem manuscript. This manuscript won the Schultz-Werth Research Award at South Dakota State University and five hundred dollars. This book is an account of my life. It chronicles some of the things I've seen and done from hog slopping to visiting the Amon Carter Art Museum. From the Milwaukee zoo to a thunderstorm in Pinetop, Arizona. It contains bits of historic fact and fiction. I take you along across the United States. I transport the reader with me back to the 1950's for a gentle summer day. We go on a tour of the Cudahy Packing Plant, coyote hunting, pheasant hunting, grave digging and taking out the trash. We survive a train wreck, a flying saucer and a South Dakota blizzard. Through it all the writing prevails. EAN13: 978-1981523375 Page Count: 132 Binding Type: US Trade Paper Trim Size: 6" x 9" Language: English Color: Black and White Related Categories: Poetry / General. Find it available wherever fine books are sold. Check with your local book store or favorite online bookstore.

Stalking Spirits

The STALKING Spirits a book of nitty-gritty poetry. From the "Grey Sidewalk Man" to the "The Copper Queen," the people in this collection are hanging on tight. The scenery shifts from Texas to Arizona to New Mexico to Kansas to Illinois and to Canada. The subjects vary from drunk rolling, to picking gooseberries, to box turtles. All reminding us of The Grand Masterflash's song "The Message" when it says, "Don't push me cause I'm close to the edge!" We too slip when that "West Texas Preacher" slides in the mud down into the hole at the graveside service he is preaching in the rain. We feel the bewilderment when the ER nurse asked us to move our feet and we've been sitting so long that we can't feel them, don't know where they are. Through it all, the words take us there and bring us back EAN13: 978-1981523467 Page Count: 126 Binding Type: US Trade Paper Trim Size: 6" x 9" Language: English Color: Black and White Related Categories: Poetry / General. Find it available wherever fine books are sold. Check with your local book store or favorite online bookstore.

Again, The Poplars Spread Their Bitter Scent

Again, The Poplars Spread Their Bitter Scent is a delightful book of poetry. Over the past 20 years, his poetic work became well known in Russia and abroad thanks to numerous publications. His poems systematically appear in various Anthologies and are published in the journals New Literature (Russia), Libelle (France), Pluma y tintero (Spain), Episteme, Our Poetry Archive (India), The World Poets Quarterly (China). Recently in Germany were published 5 books of his poetry: Jungle of Love, Crooked Mirrors of Imagination, Unknown eternal chains, the time has come to sum up, River of Life. Adolf Shvedchikov is a romantic poet. He is the master of love lyrics. But for him, love lyrics are not an independent goal. He tries to understand the whole spectrum of relationships between a man and a woman, to find the secret of a harmonic world in the categories of love. A great place in the poet's work is the theme of the relationship between a person and the world around him. He tries to find the philosophical meaning of life and wants to understand what human capabilities are in a relatively short time of his existence. **English Version:** EAN13: 978-1984985507 Page Count: 60 Binding Type: US Trade Paper Trim Size: 6" x 9" Language: English Color: Black and White Related Categories: Poetry / General. **English/Russian Version:** EAN13: 978-1981518135 Page Count: 110 Binding Type: US Trade Paper Trim Size: 6" x 9" Language: English Color: Black and White Related Categories: Poetry / General. Find it available wherever fine books are sold. Check with your local book store or favorite online bookstore.

William Shakespeare SONNETS

Over 150 Romanized SONNETS of William Shakespeare are now translated into Russian thanks to Dr. Adolf Pavlovich Shvedchikov Russian scientist, poet and translator. The William Shakespeare SONNETS translated in Russian is the perfect companion for students, teachers, colleges, universities or anyone studying the exquisite Russian language. **English/Russian Version:** EAN13: 978-1985131163 Page Count: 172 Binding Type: US Trade Paper Trim Size: 6" x 9" Language: English Color: Black and White Related Categories: Classic / Poetry / General. Find it available wherever fine books are sold. Check with your local book store or favorite online bookstore.

TEARS of BLISS

Readers are given the opportunity to see the collection of poems "Tears of Bliss" by the famous Russian scientist, poet and translator Adolf Shvedchikov. The reader is given the opportunity to get acquainted with the collection of poems "TEARS OF BLISS" by the famous Russian scientist, poet and translator Adolf Pavlovich Shvedchikov, whose work is well known all over the world. His poems, translated into many languages, are printed in various countries in journals and anthologies. In 2017, the German publishing house "Drugoe-reshenie" in Saarbrucken released a series of collections of his poems in Russian: "Jungle of Love; Curve mirrors of the imagination; Eternal chains of unknown; It's time to sum up; River of life; Kaleidoscope of memories; Be the flame of my soul; The world is beating convulsively." Over the past 20 years, he gained fame not only in Russia, but in many countries around the world. His poems are regularly published in international literary journals and anthologies, he is a member of various international literary societies. His books of poetry were printed in many countries (Russia, USA, Germany, Japan, Cyprus). Adolf Shvedchikov - the master of love lyrics, in his poems he constantly sings the female beauty. We hope that the book "Tears of Bliss" can be of interest to the English and Russian-speaking readers in different countries. **English Version:** EAN13: 978-1985378773 Page Count: 106 Binding Type: US Trade Paper Trim Size: 6" x 9" Language: English Color: Black and White Related Categories: Poetry / General. **English/Russian Version:** EAN13: 978-1985378056 Page Count: 118 Binding Type: US Trade Paper Trim Size: 6" x 9" Language: English Color: Black and White Related Categories: Poetry / General. Find it available wherever fine books are sold. Check with your local book store or favorite online bookstore.

www.ingramcontent.com/pod-product-compliance
Lightning Source LLC
Chambersburg PA
CBHW081708220526
45466CB00009B/2910